The Color of KENOSHA

WINTER WONDERS 2022

A Coloring Book for All-Ages
from Kenosha, Wisconsin

Created by
Donovan Scherer

**The Color of Kenosha - Winter Wonders 2022:
A Coloring Book for All-Ages from Kenosha, Wisconsin**

Text & Illustrations Copyright © 2022 by Donovan Scherer

Published in 2022 by Studio Moonfall LLC

All rights reserved.

This is a work of fiction. Names, characters, places, and incidents are products of the author's imagination or are used fictitiously. Any resemblance to actual events, locales, organizations, or persons, living or dead, is entirely coincidental.

No part of this book may be used or reproduced in any manner whatsoever without written permission, except in the case of brief quotations embodied in critical articles or reviews.

For information regarding permission, write to:

Studio Moonfall LLC
5031 7th Ave
Kenosha, WI 53140

ISBN: 978-1-942811-34-3

www.StudioMoonfall.com

MADE IN KENOSHA

Welcome to the sixth Color of Kenosha coloring book!

If everything goes according to plan, this will be the final winter edition of the Color of Kenosha series. For 2023, we're going super jumbo sized for the summer editions to bring them out to the local markets before we get buried in snow.

But since we're here now, let's bundle up, throw on the hot cocoa, and color some of Kenosha's winter wonders in the pages of this book.

And if you dare to venture out into the cold for the holidays, be sure to pay these places a visit. You can even see what else we're publishing at Studio Moonfall, like these books over on the left side. Zombie beans and farting unicorns, made right here in Kenosha!

Happy coloring!

– Donovan Scherer

SPECIAL THANKS TO ALL THE BUSINESSES INVOLVED IN MAKING THIS BOOK

Ace Hardware - Prairie Side
Actor's Craft
AcuWell Integrative Health
Art Space Podcast
BAKaron
Blue House Books
Bluehorn Digital
CCW Studios
Charging Bull Automotive
Fear & Sunshine
Felicia Pavlica Team
Harvey Van Meter - Berkshire Hathaway
Headquarters - Shoe Soldier
Hookz & Stitchez
Kenosha Area Chamber of Commerce
Kenosha Transit
Lemon Street Gallery
Midwest DJ Productions
Nights at the Northside - Kenosha Public Library
Olympus Fitness
One Artsy Cookie
Portside Catering
Sherwood Forest Meat Market
S.P. Photography
Studio Moonfall
The Lettering Machine
The Stella Hotel & Ballroom
The Coffee Pot
Ties That Bind Publishing
Visit Kenosha

LEARN MORE ABOUT THEM AT:
www.ColorOfKenosha.com

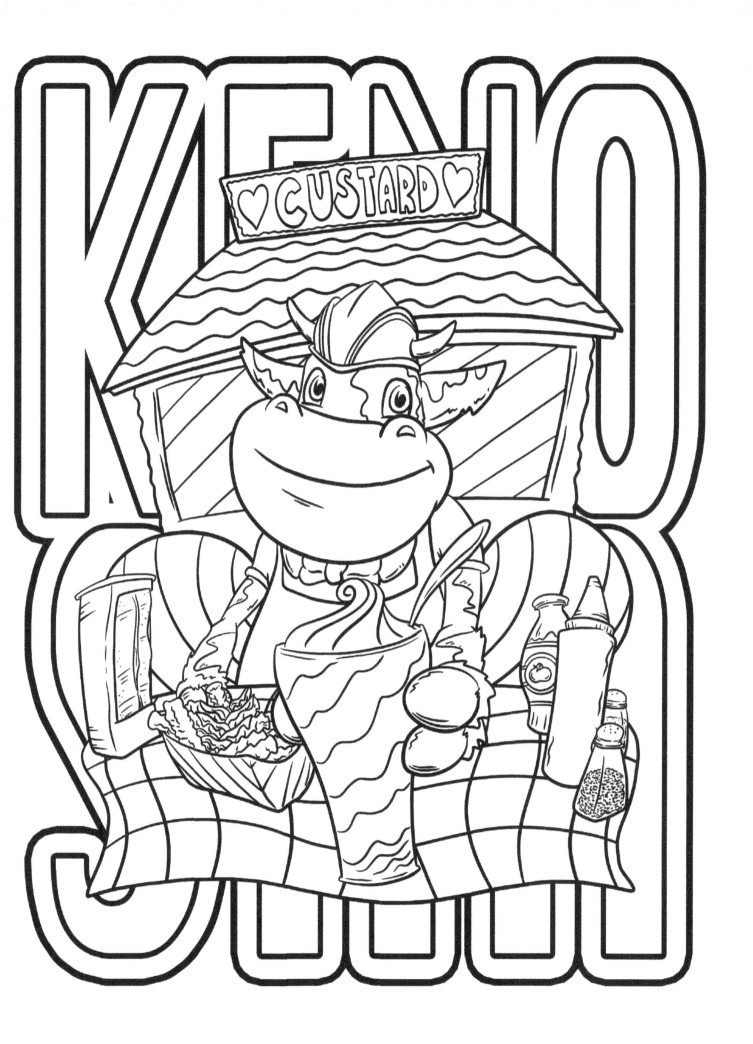

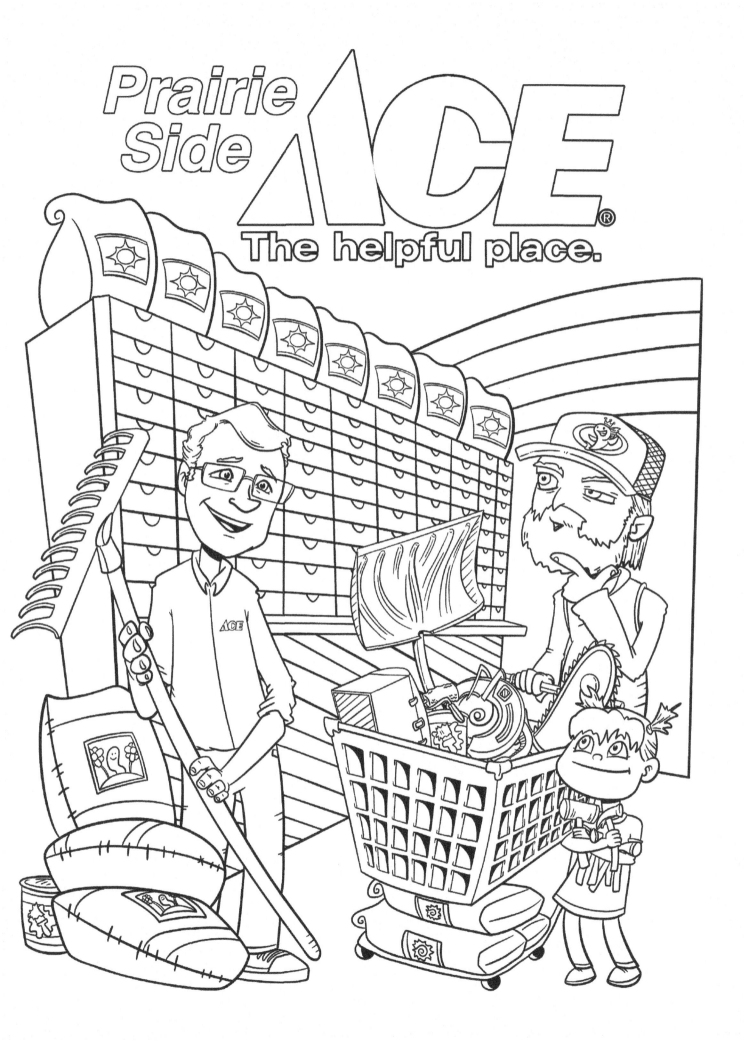

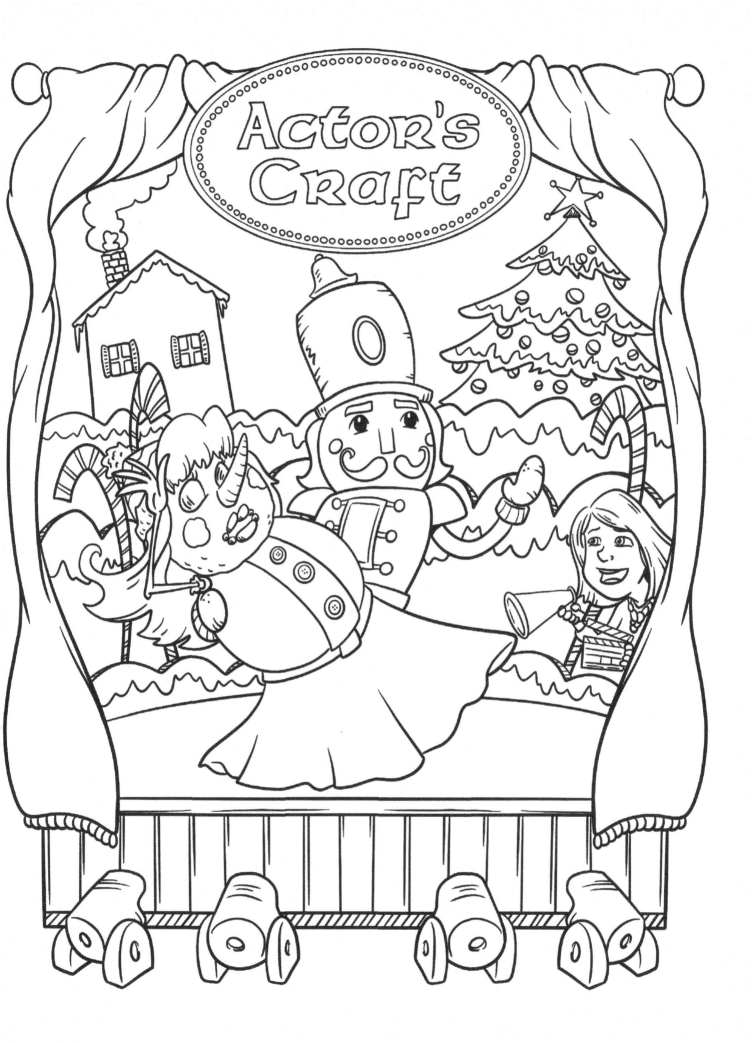

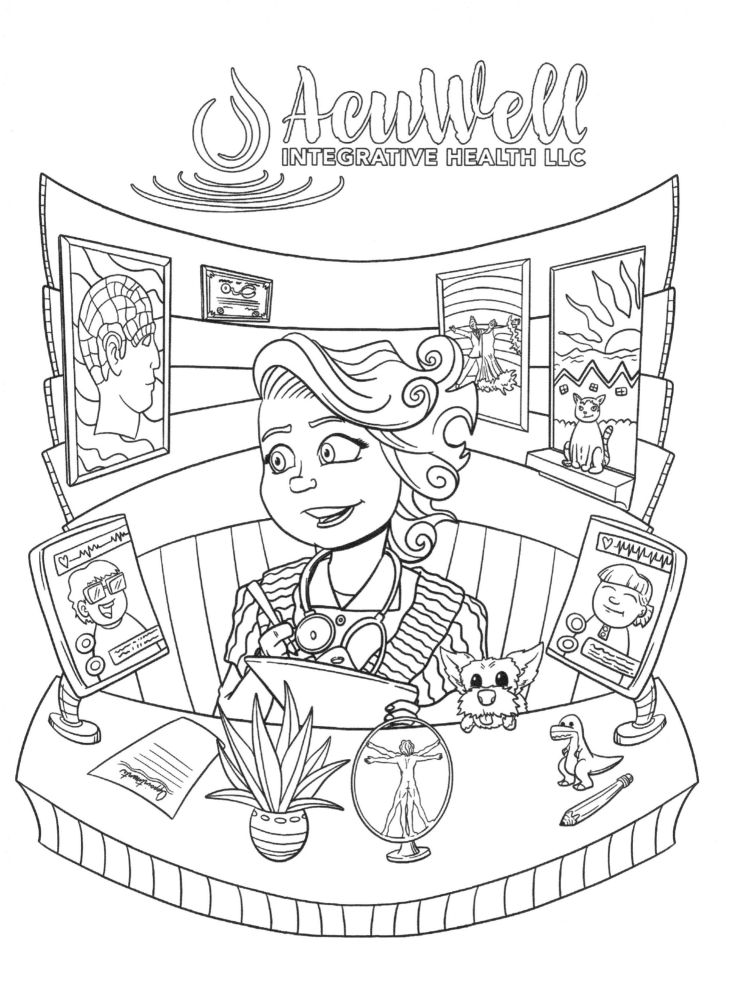

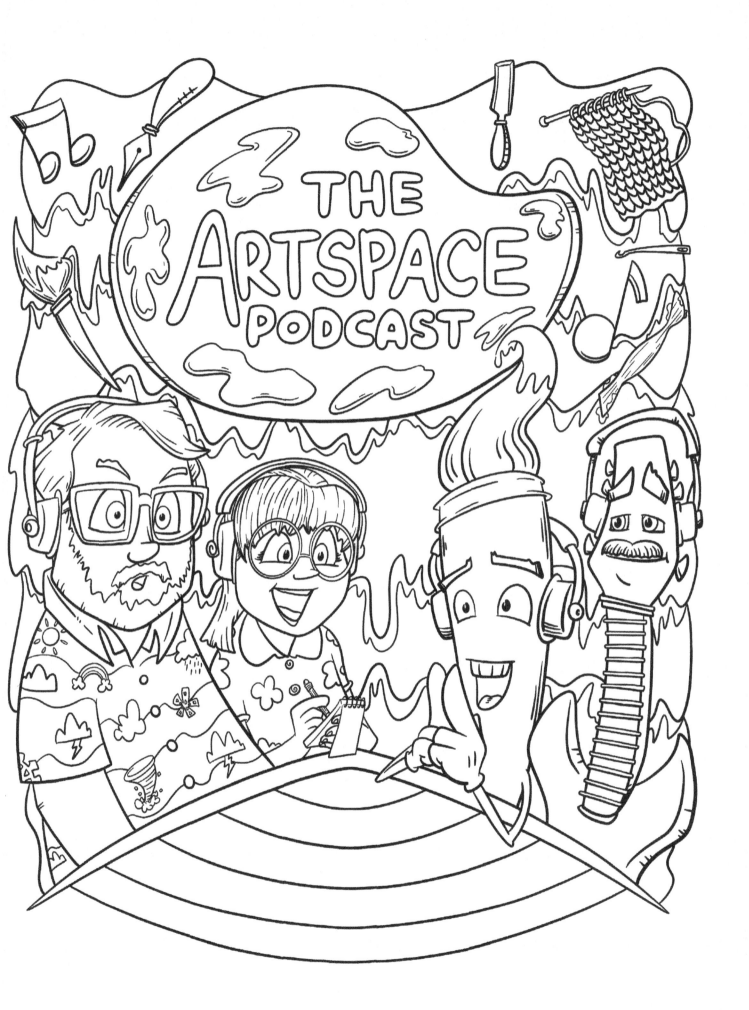

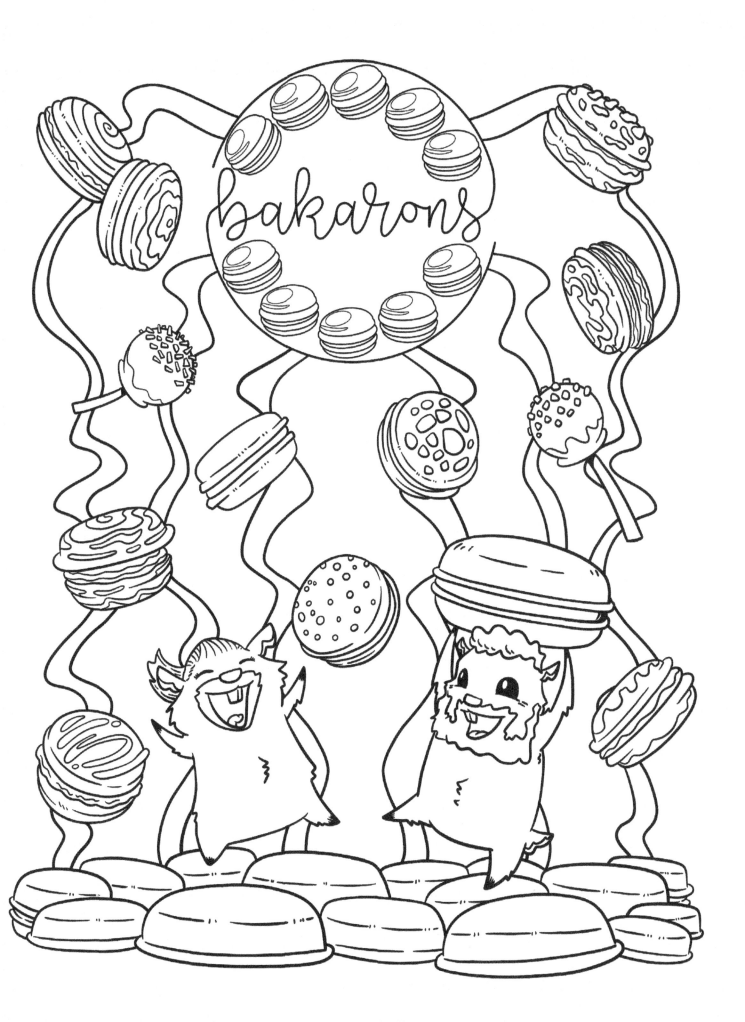

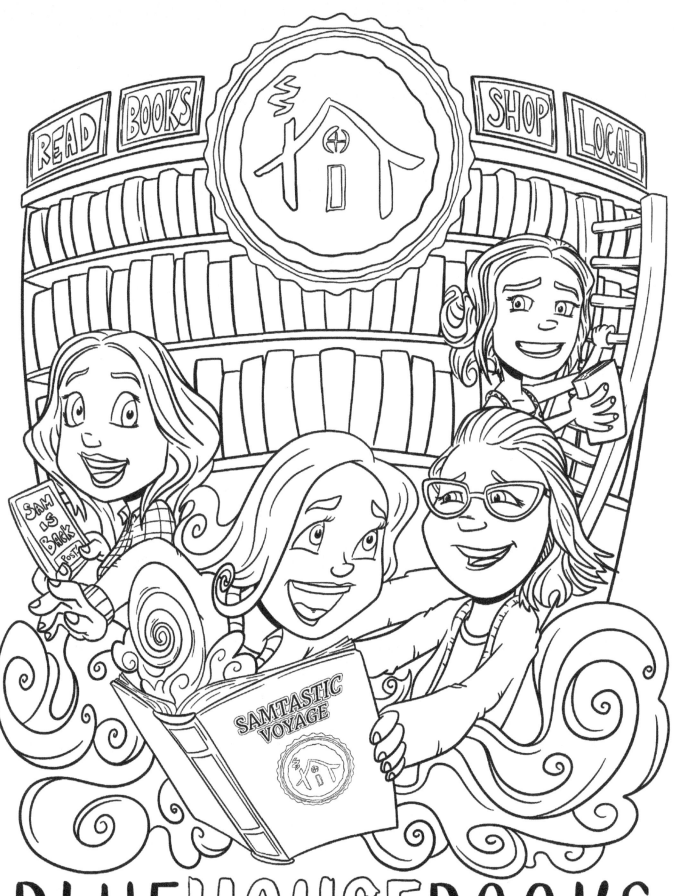

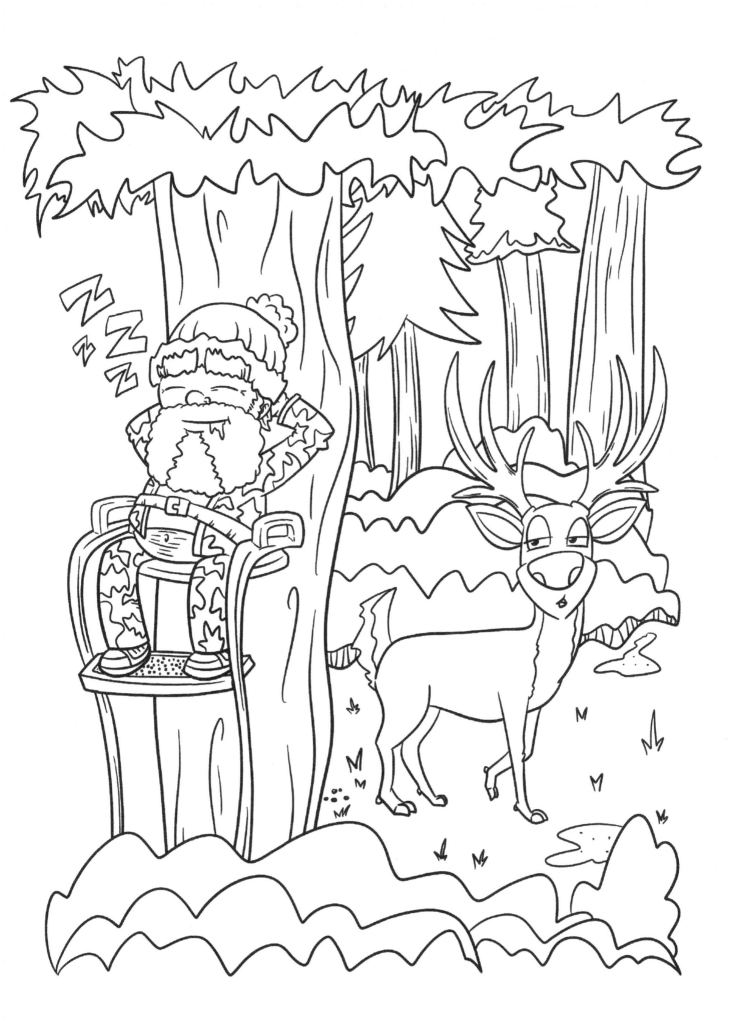

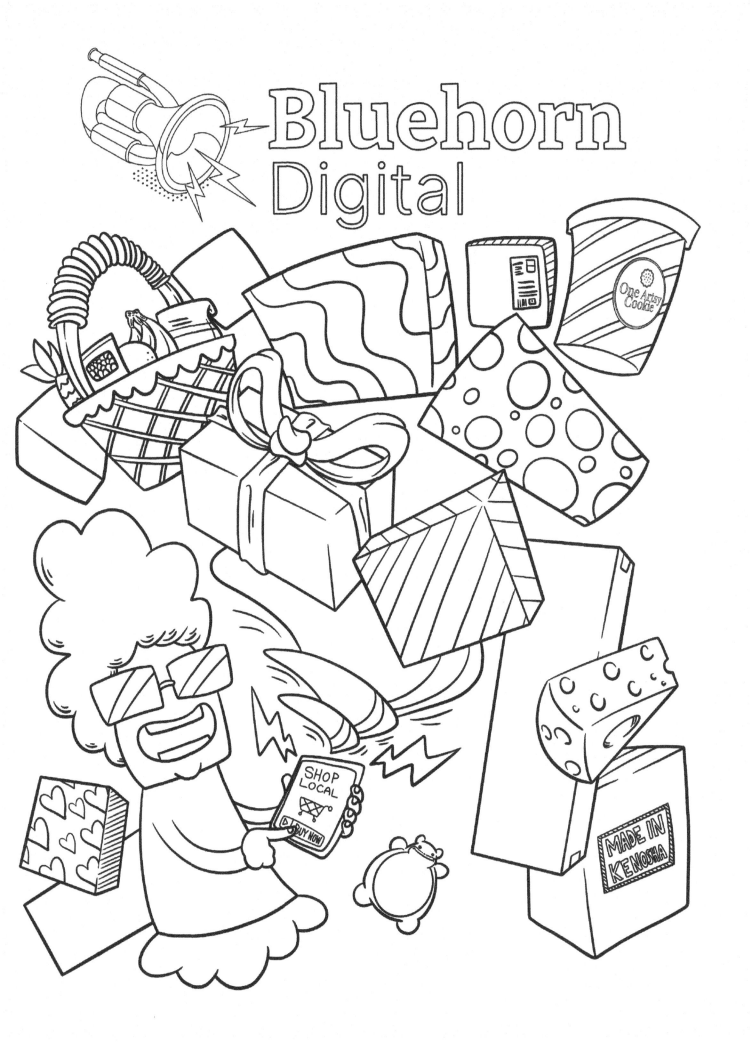

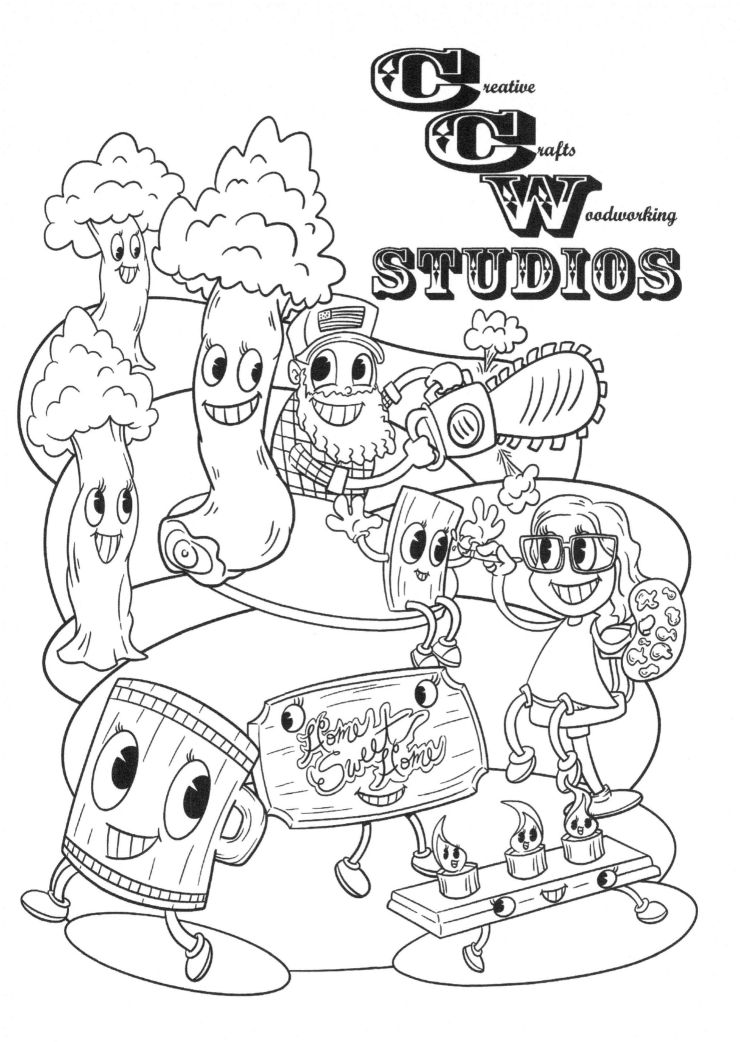

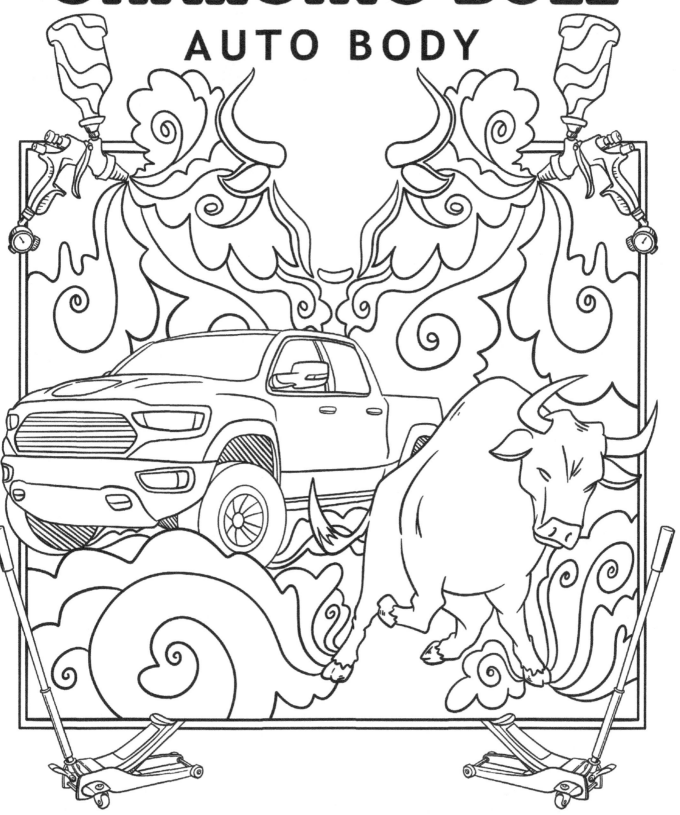

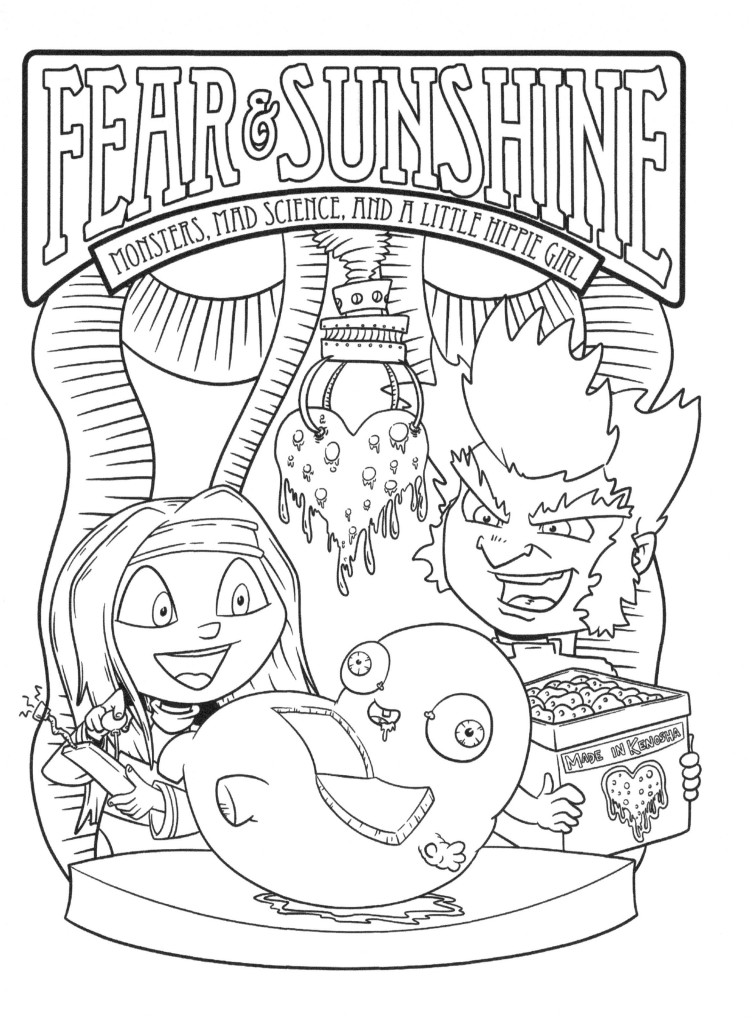

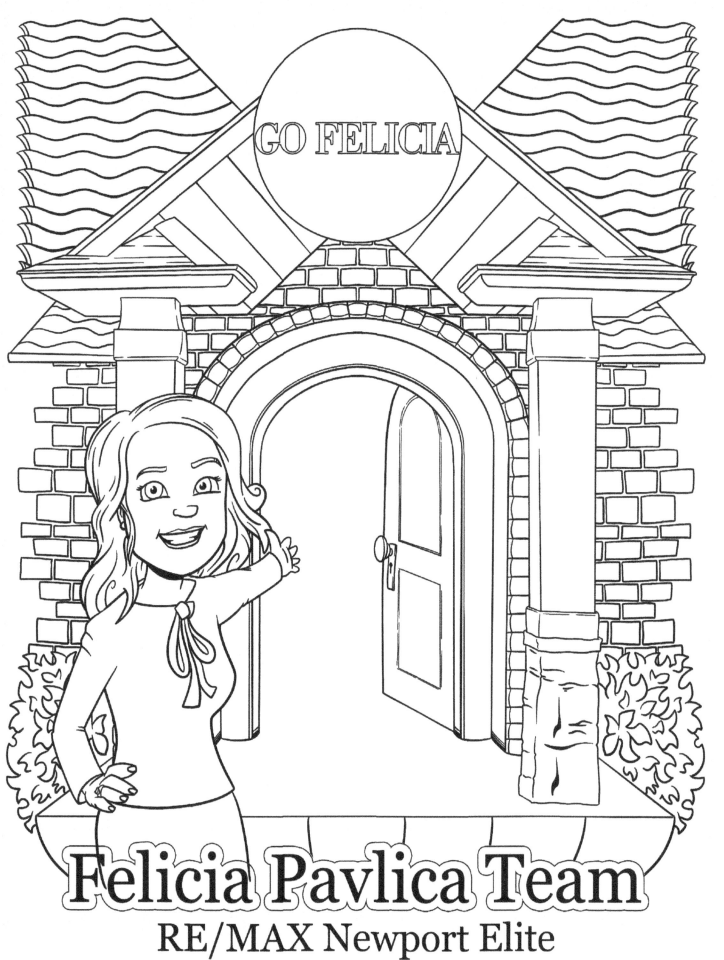

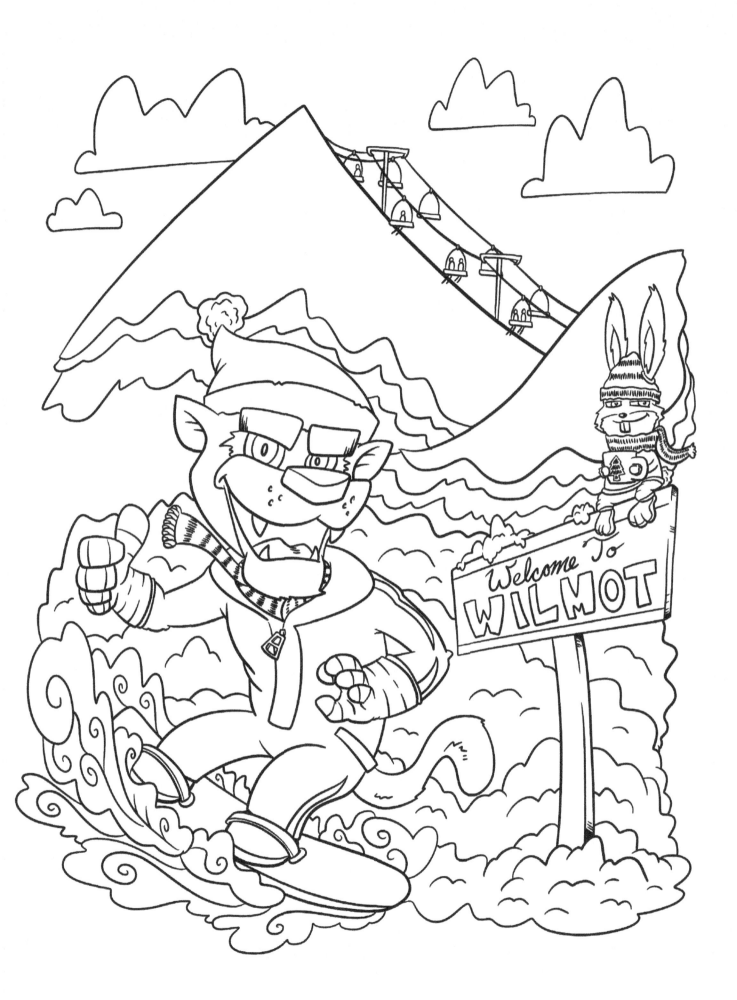

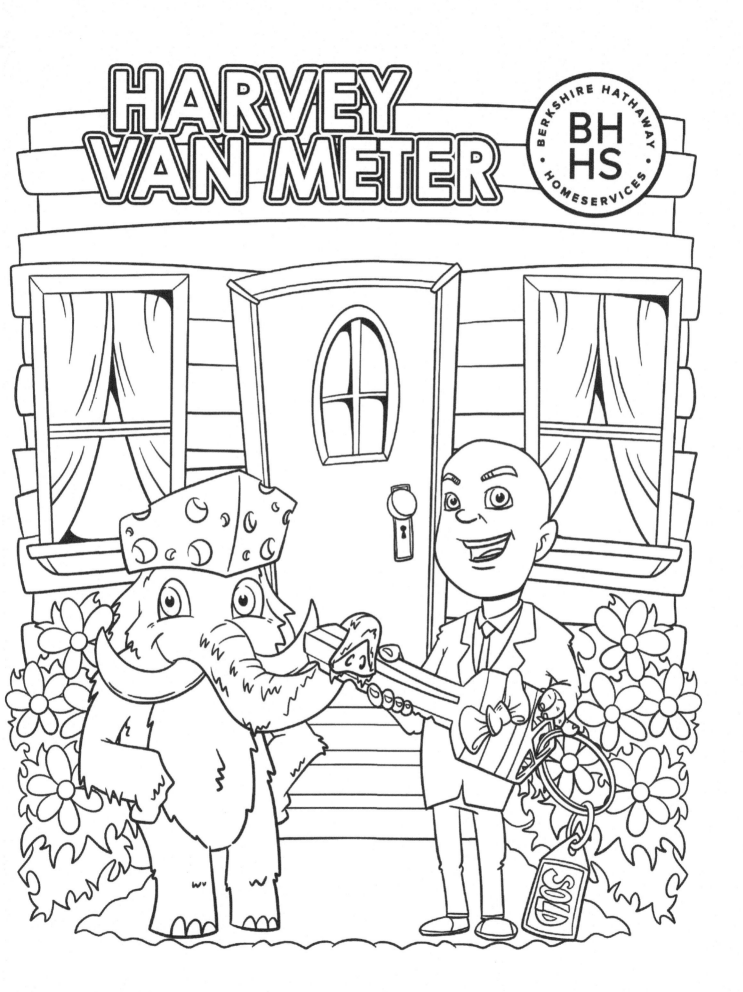

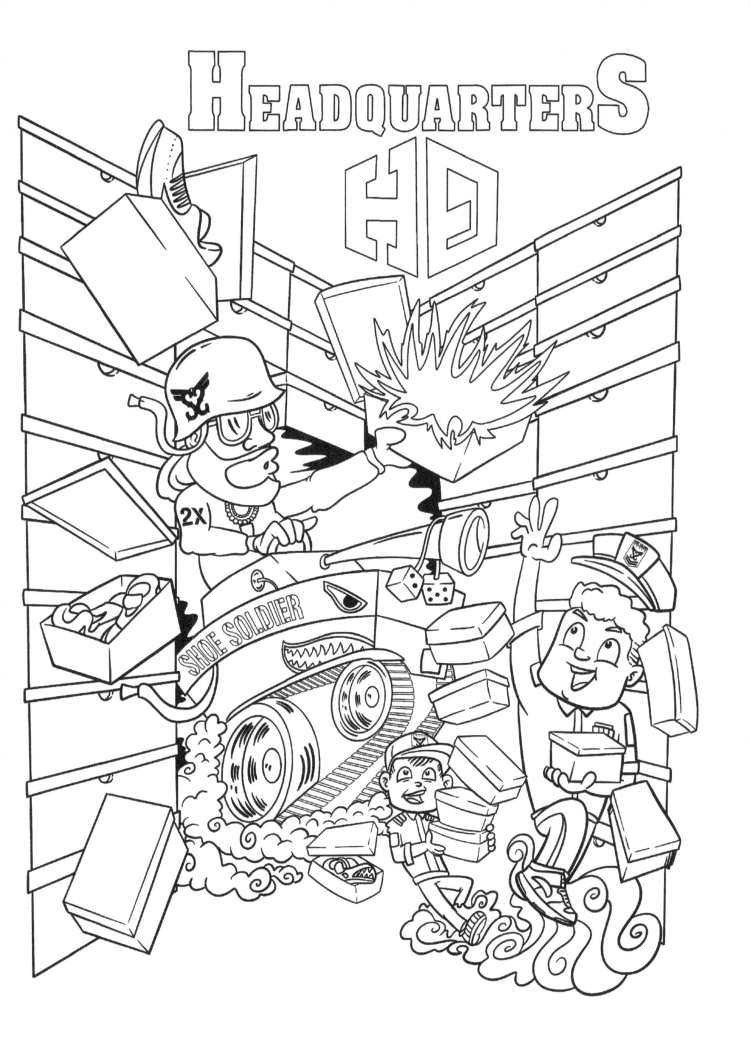

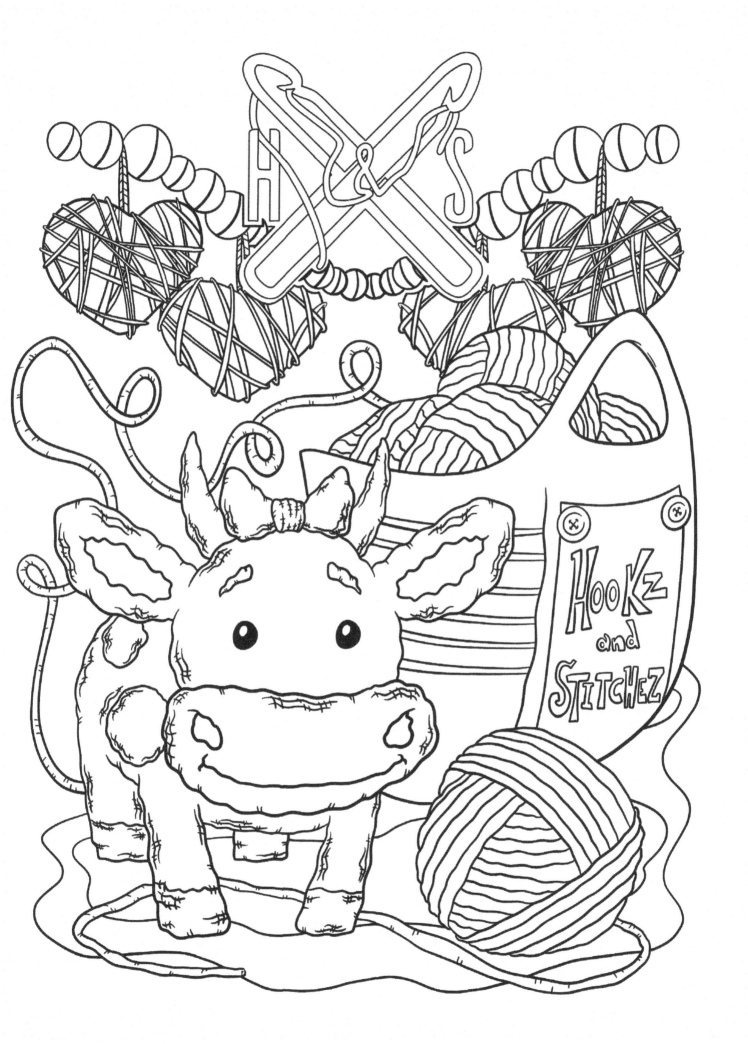

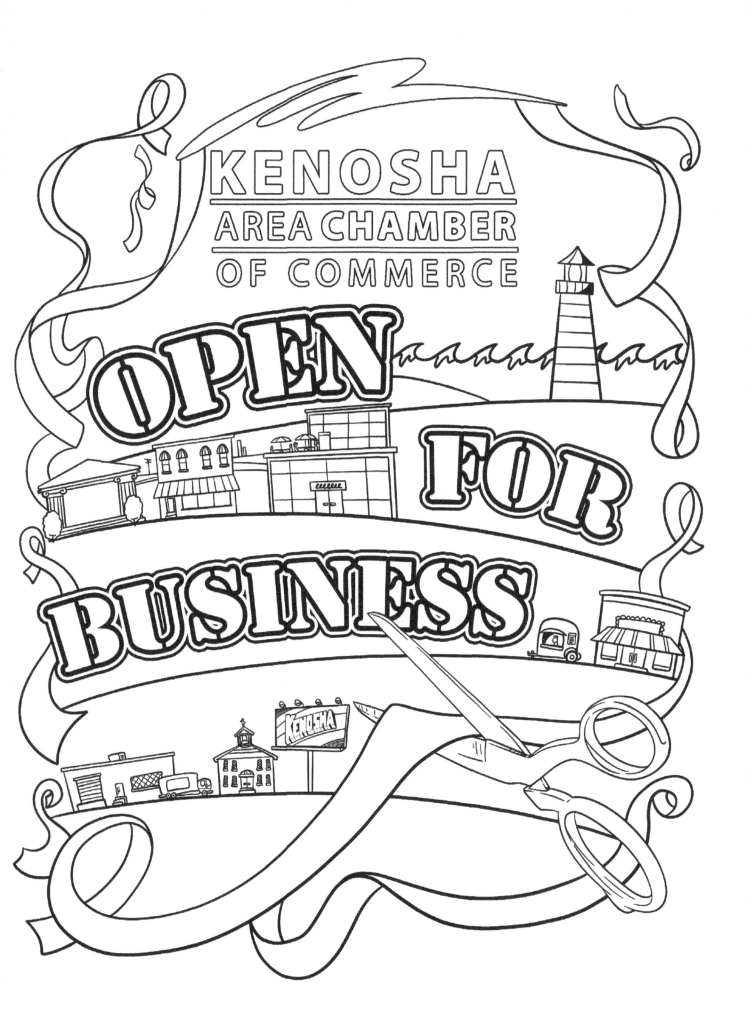

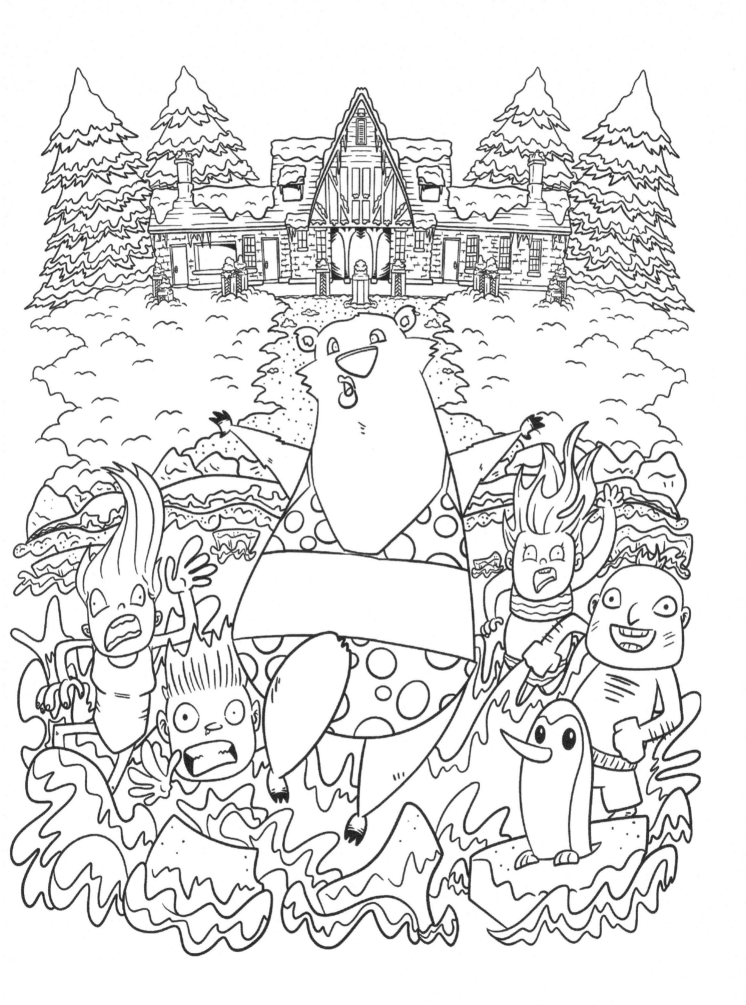

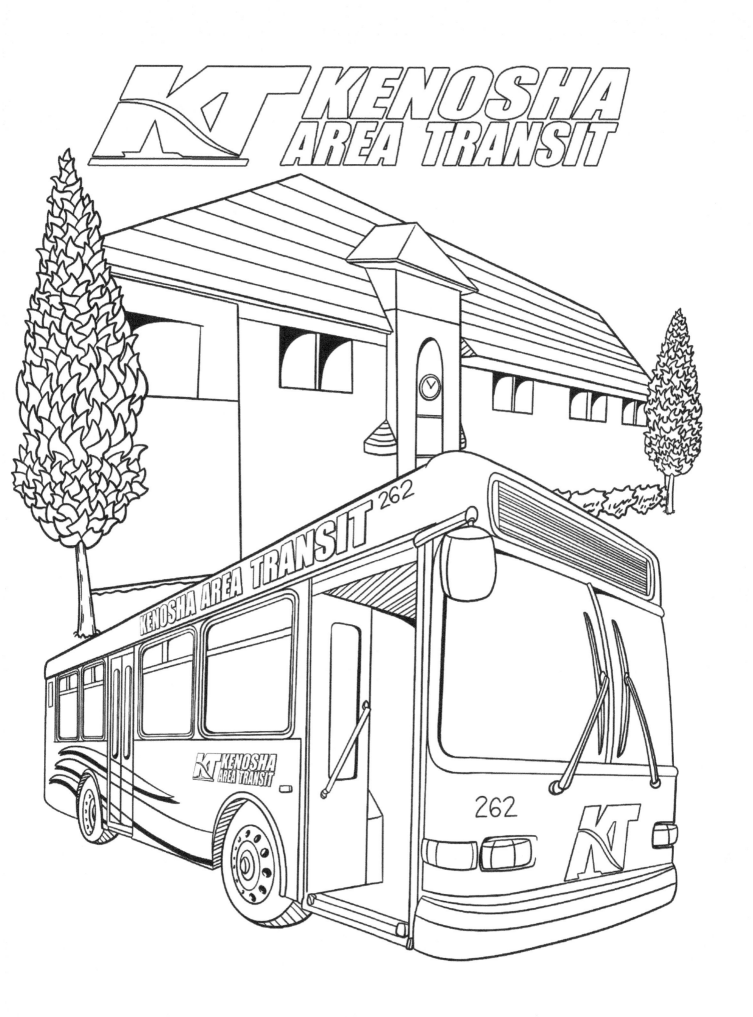

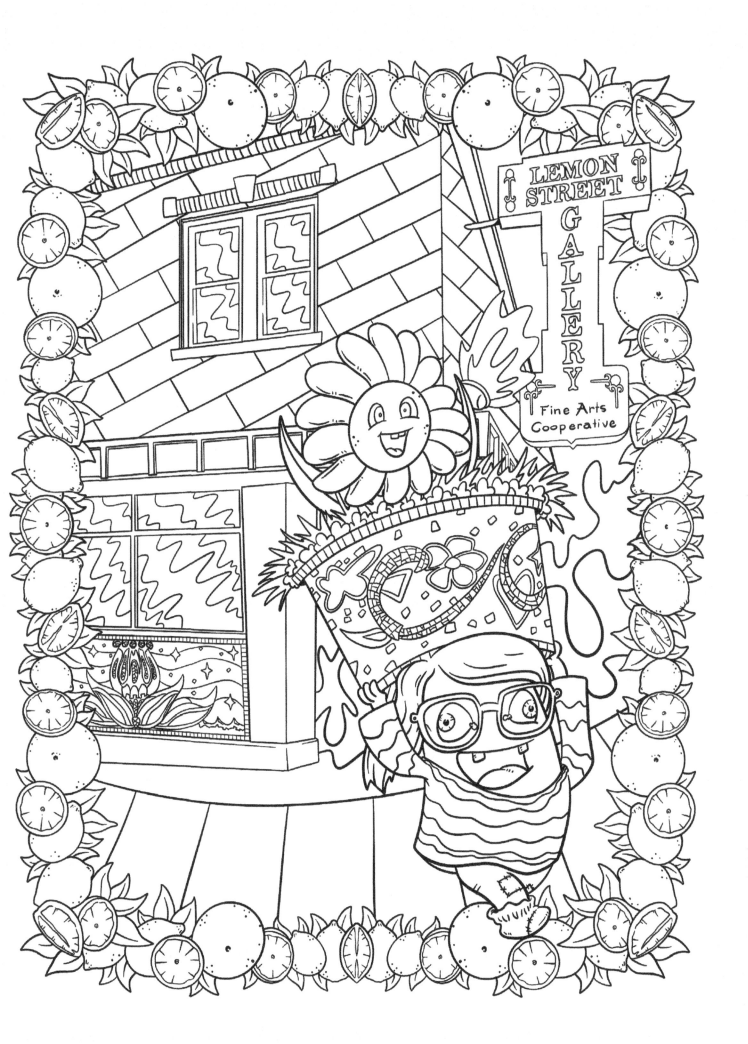

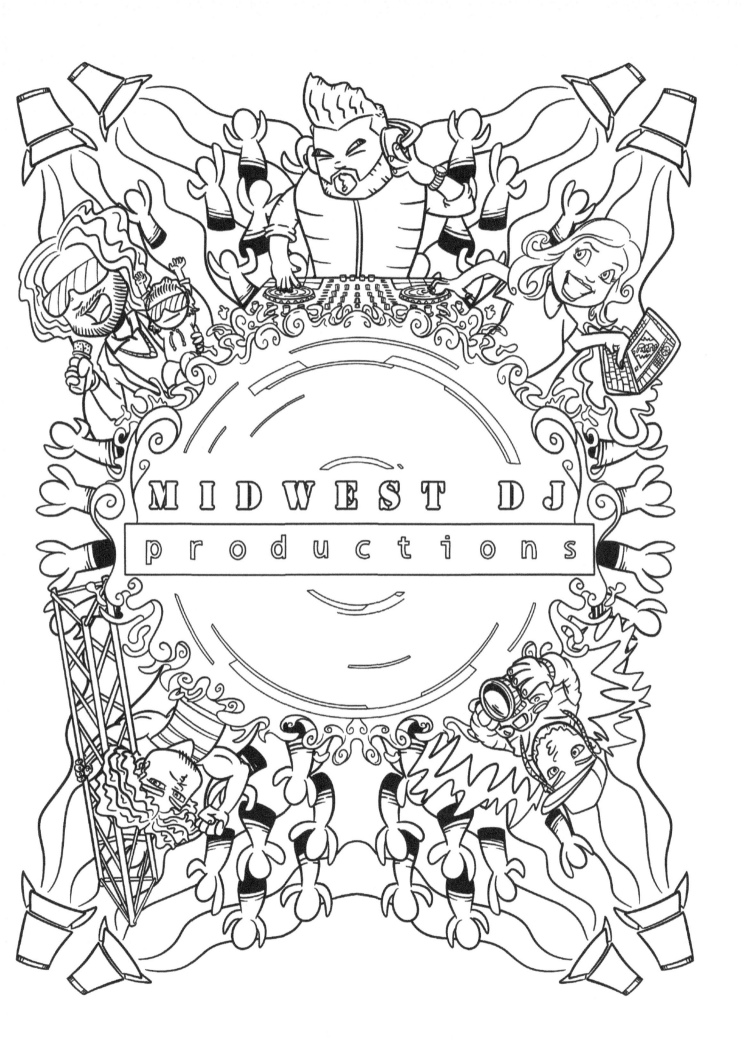

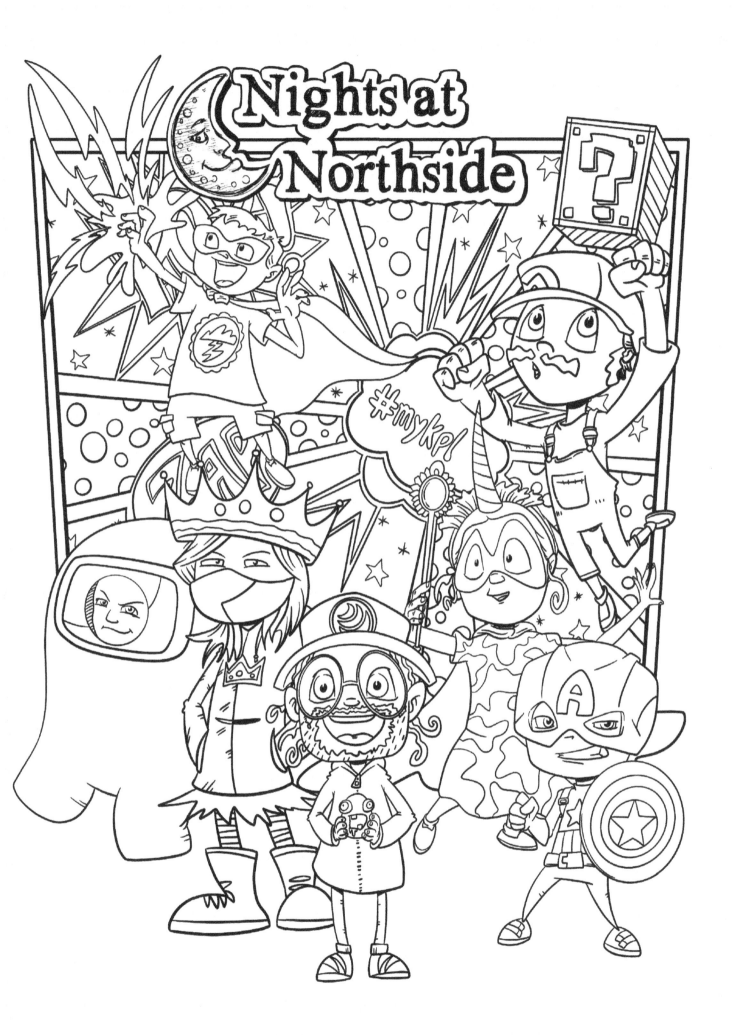

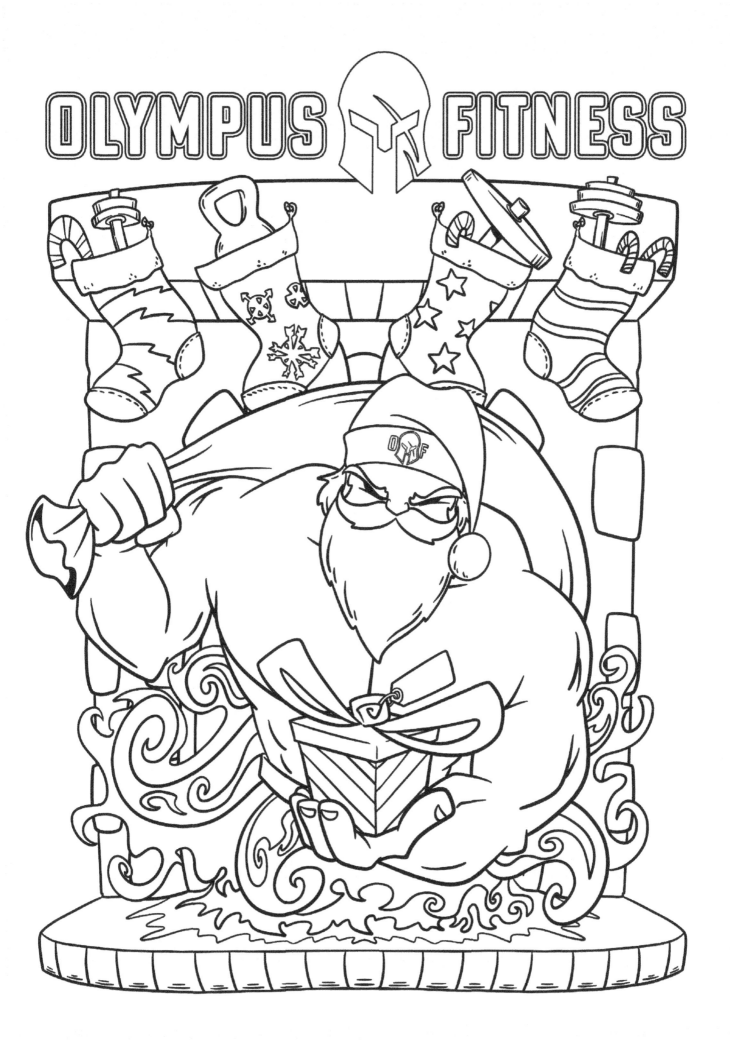

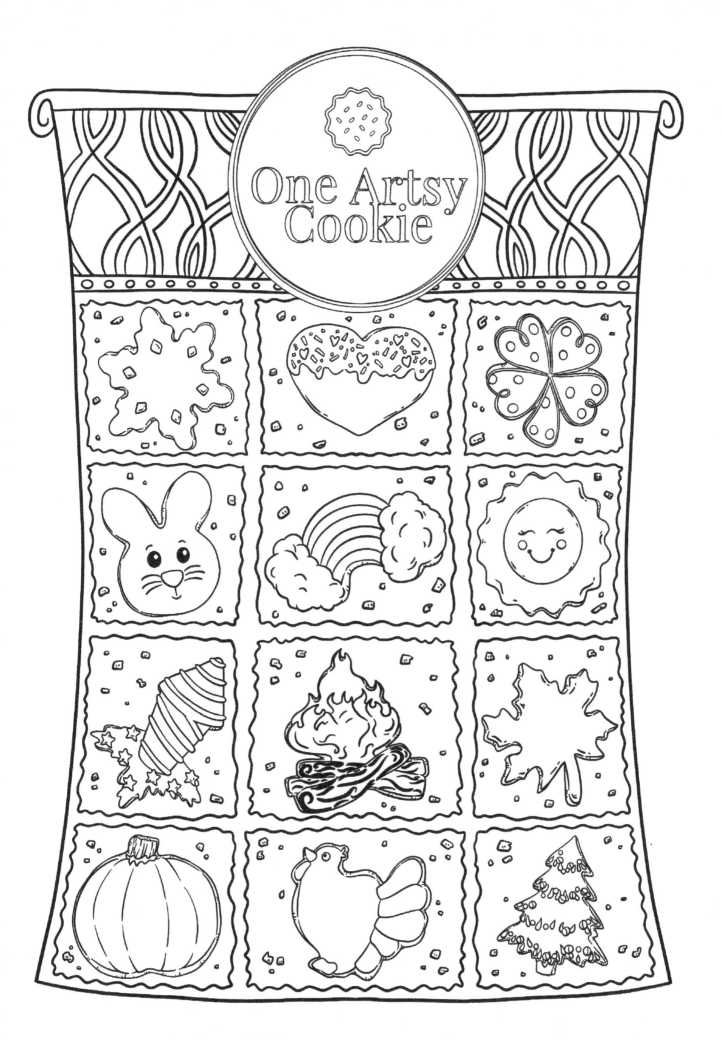

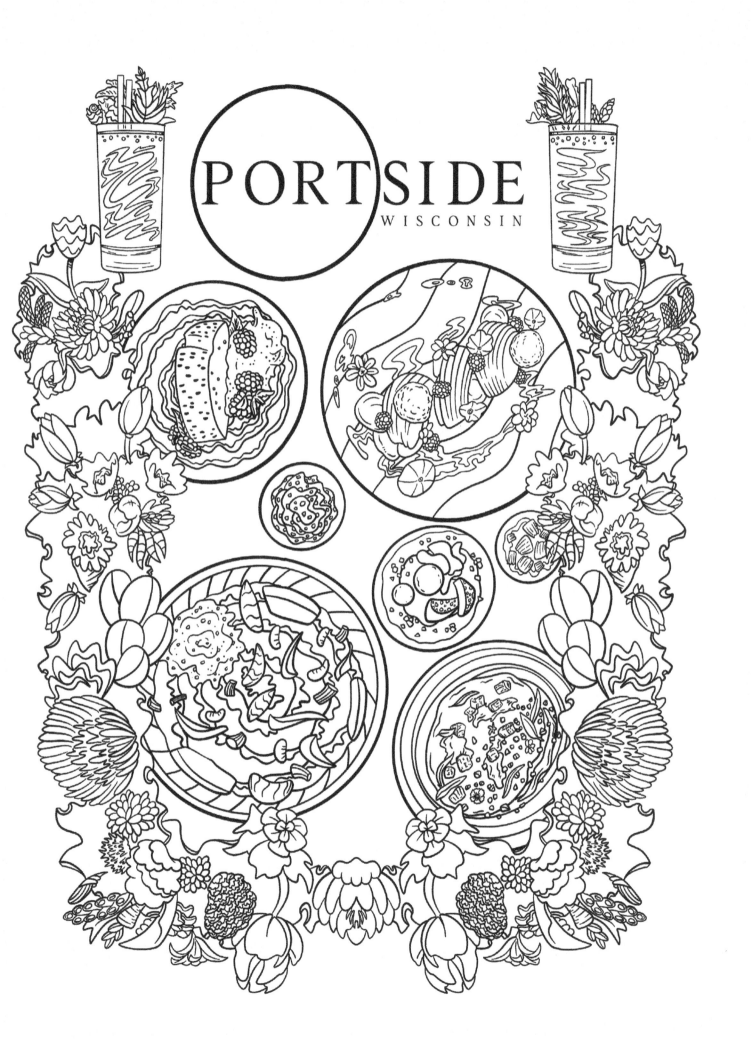

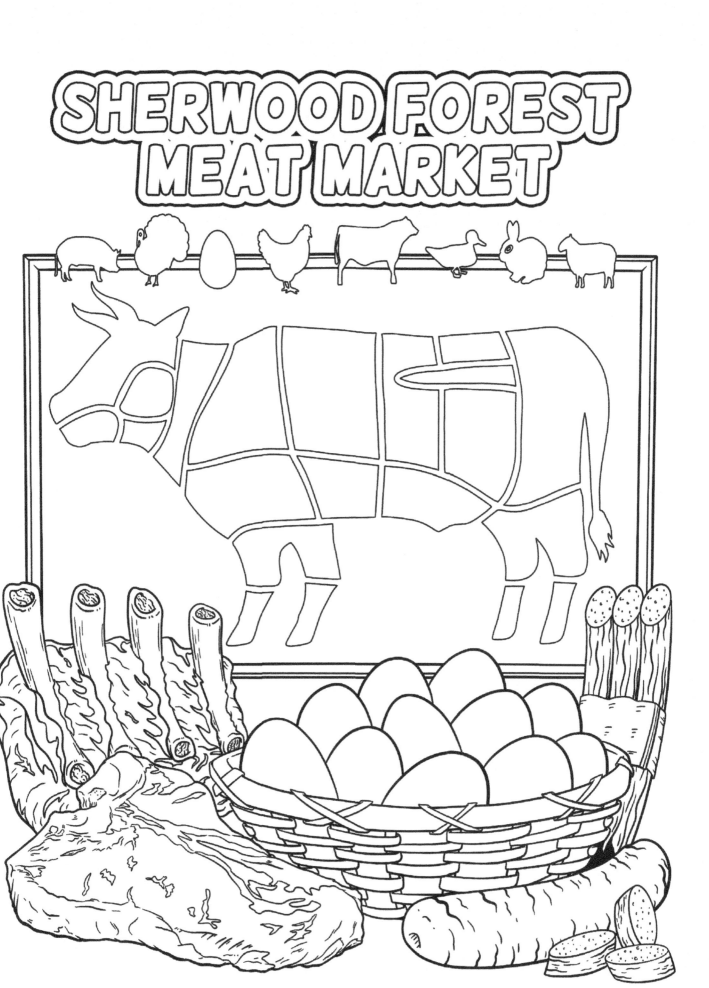

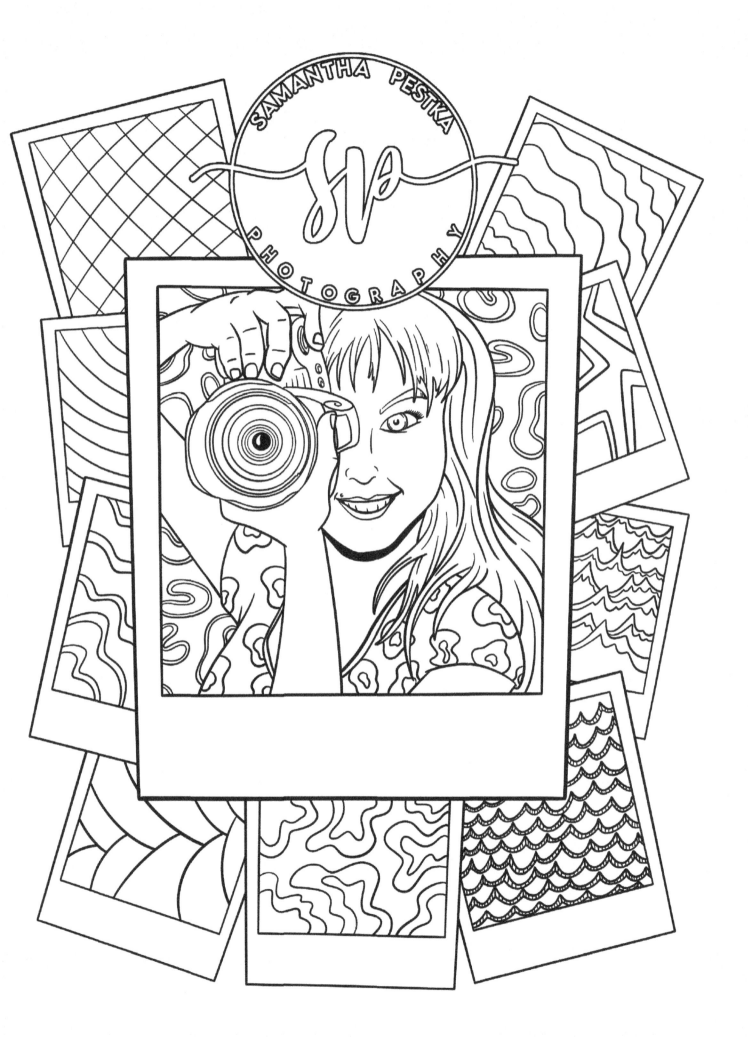

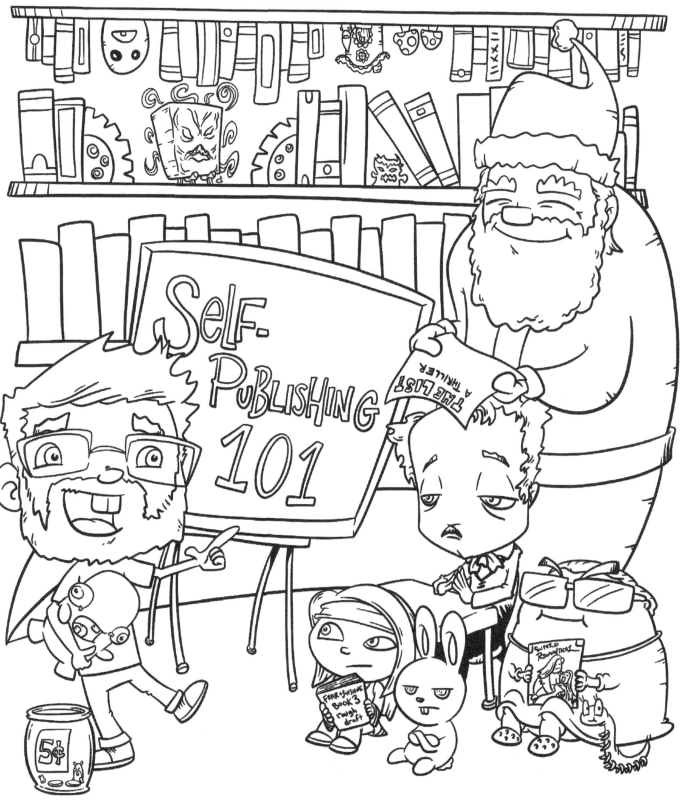

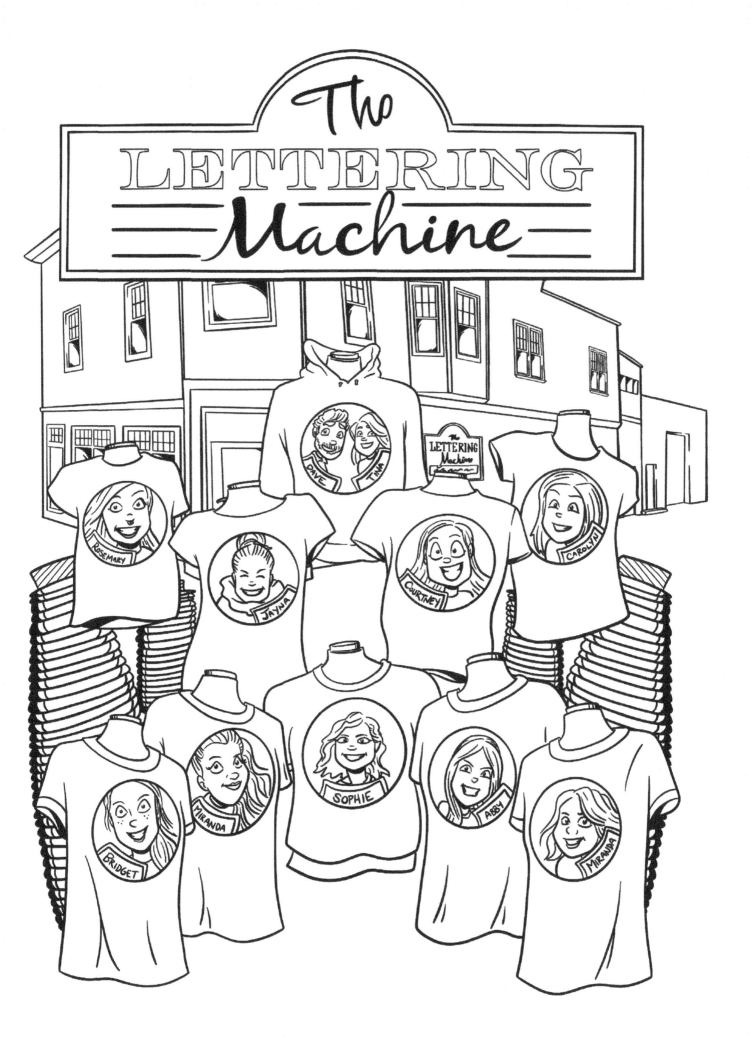

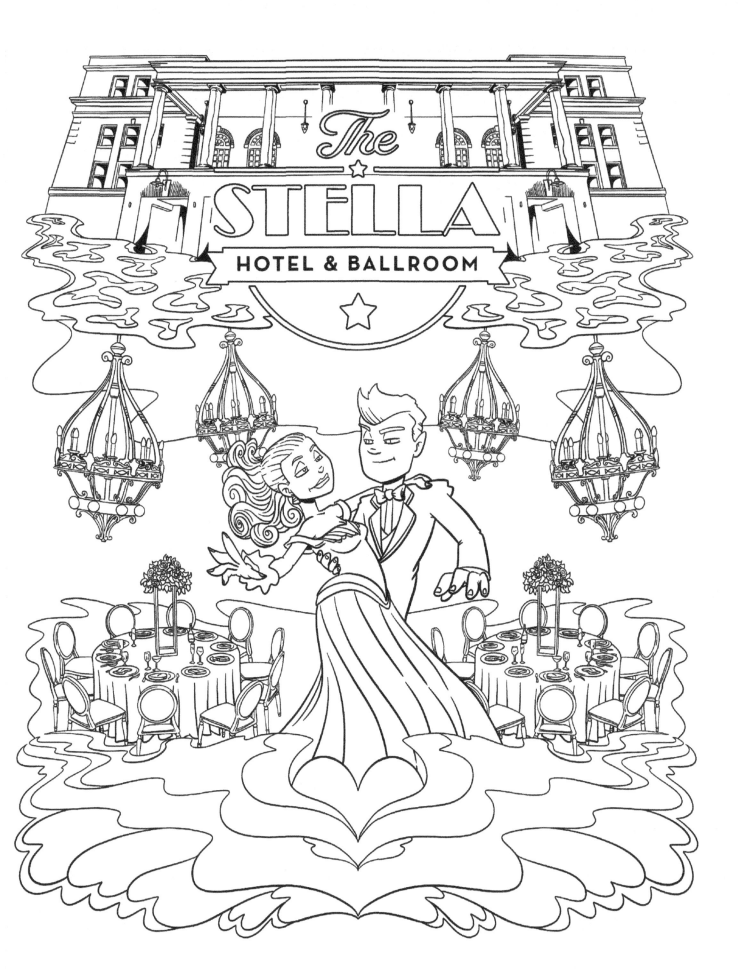

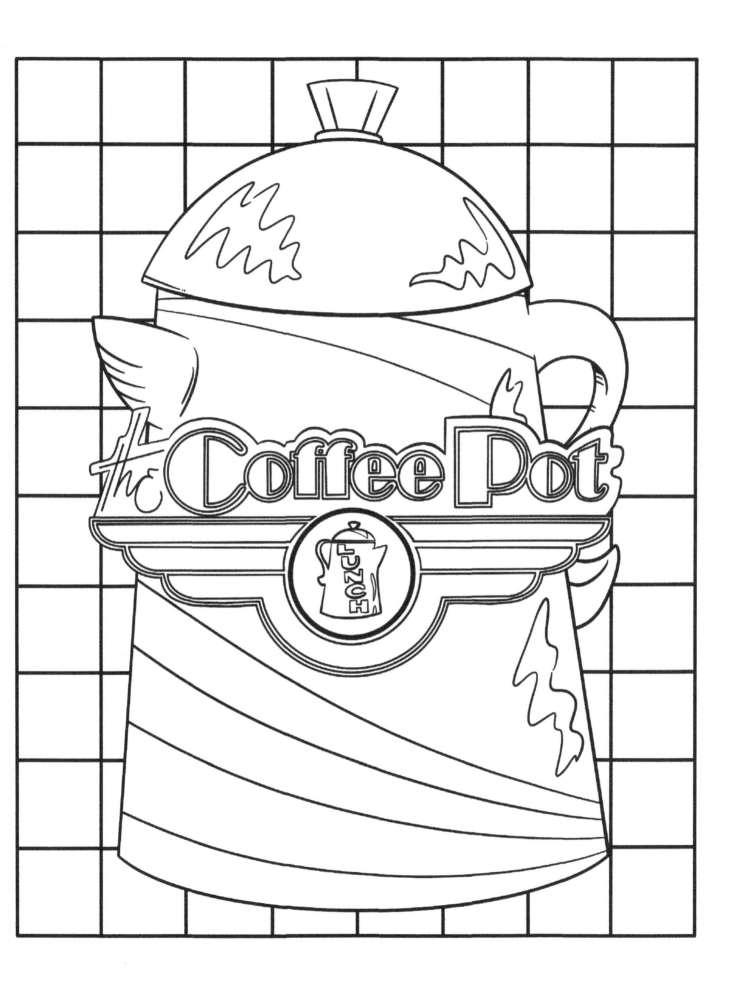

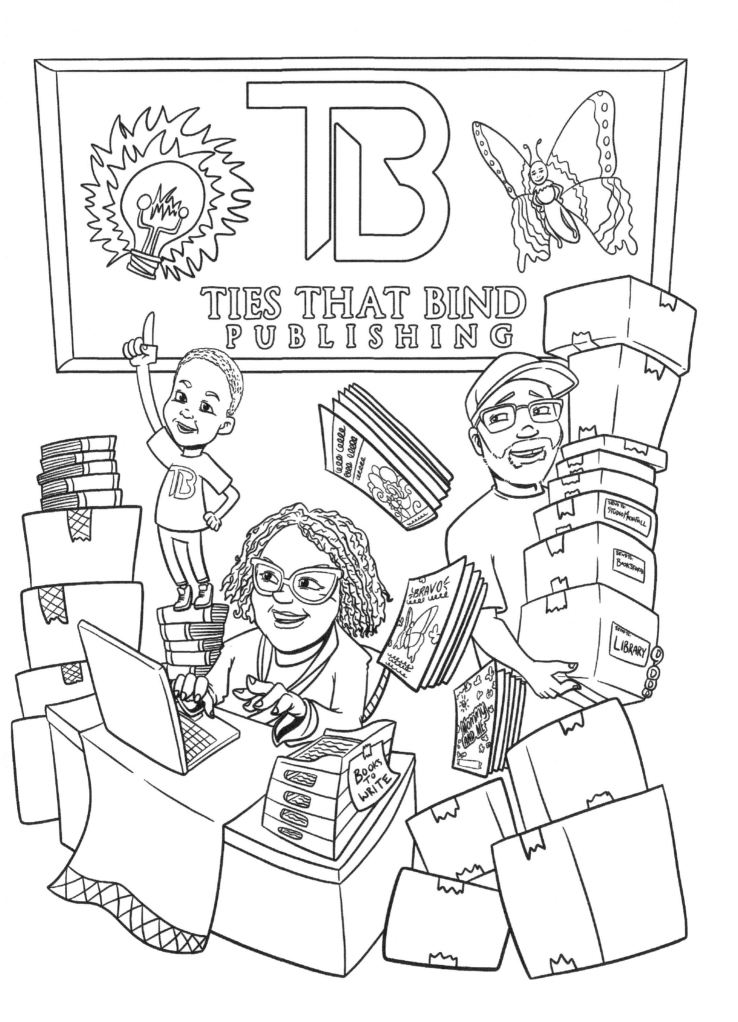

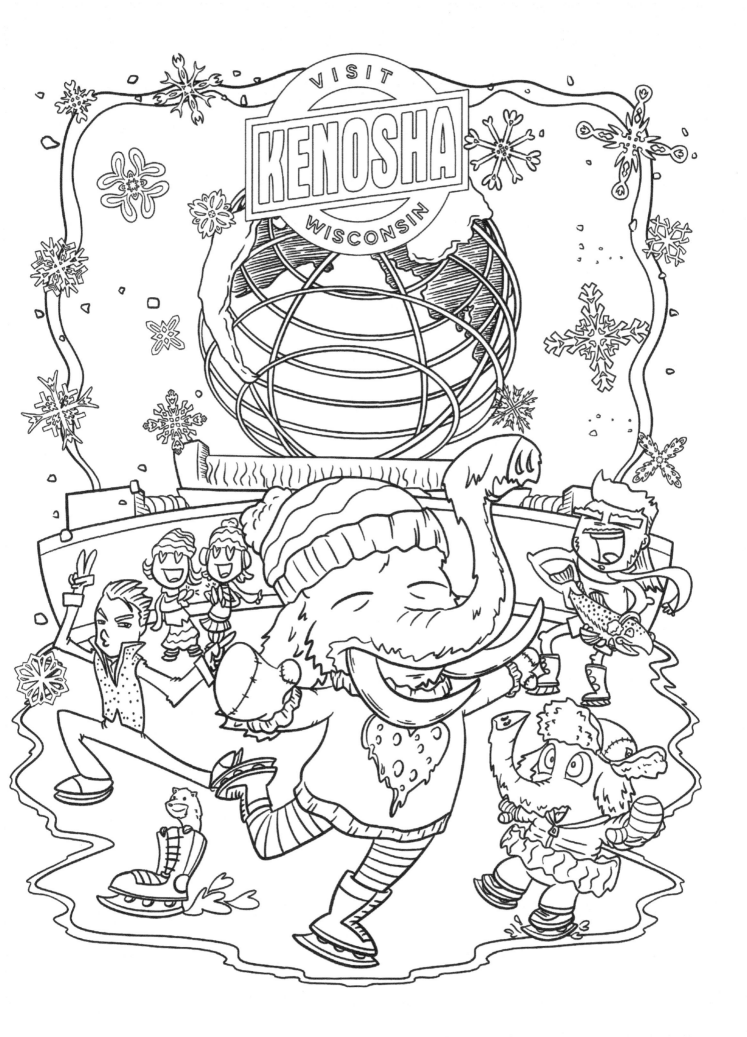

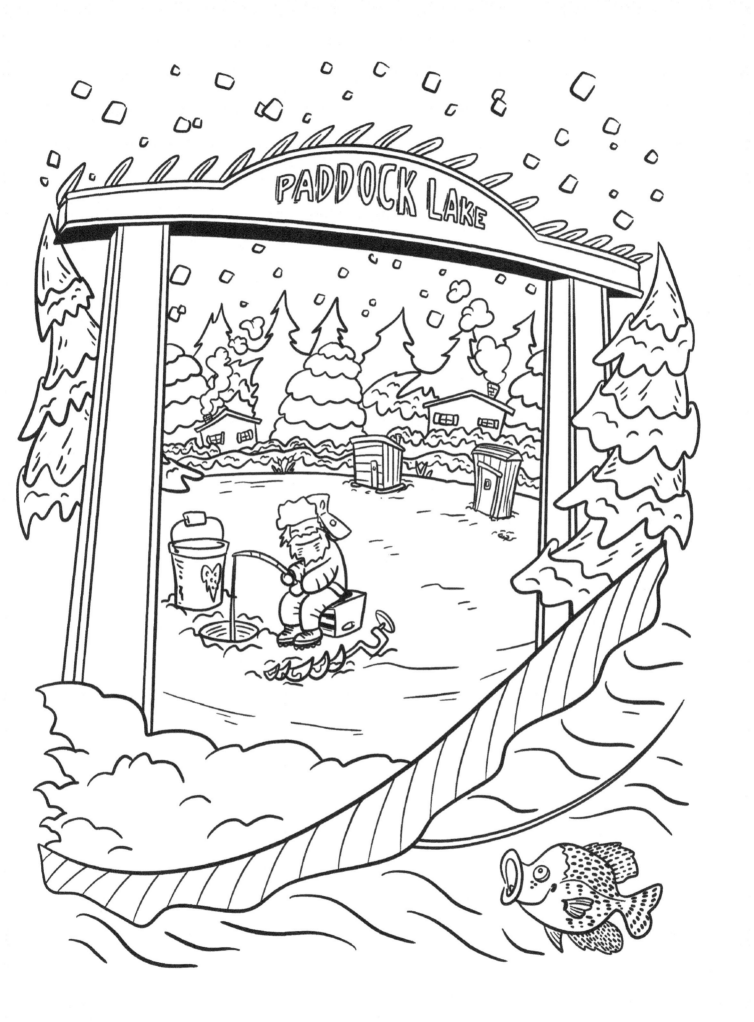

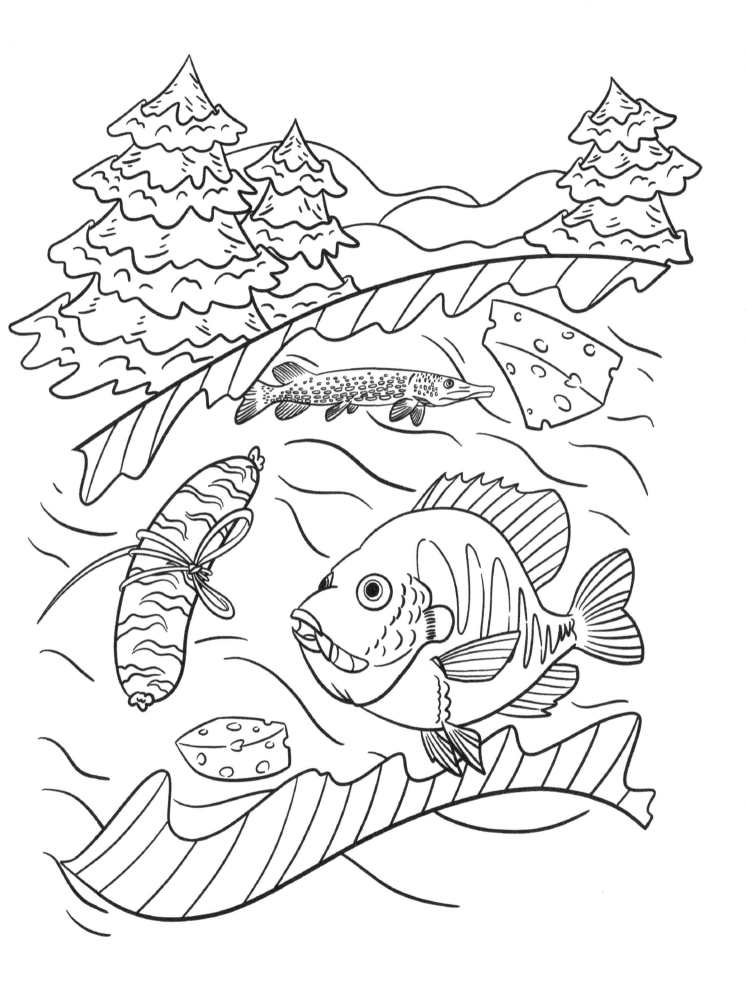

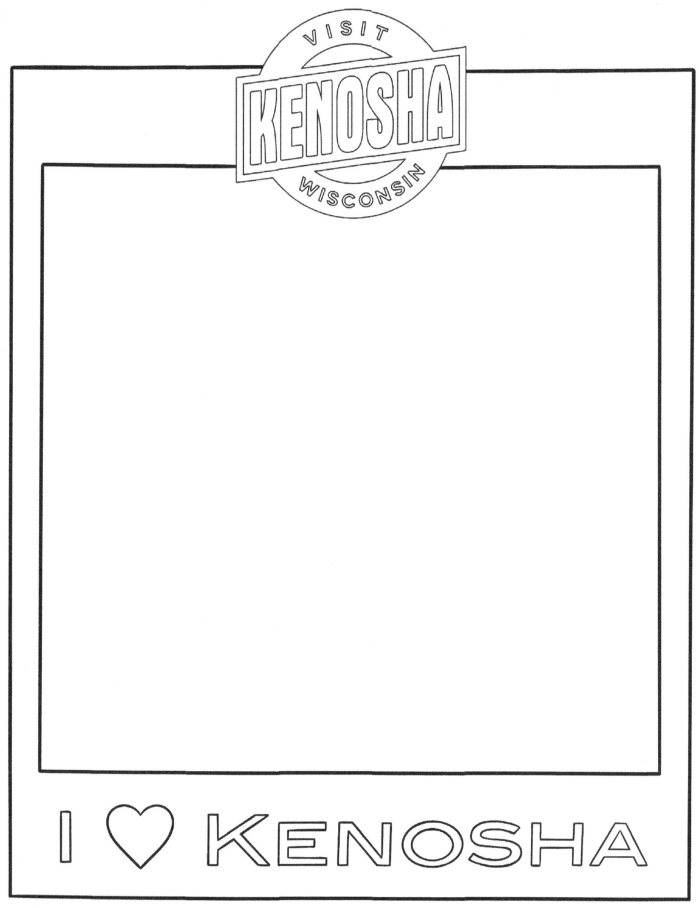

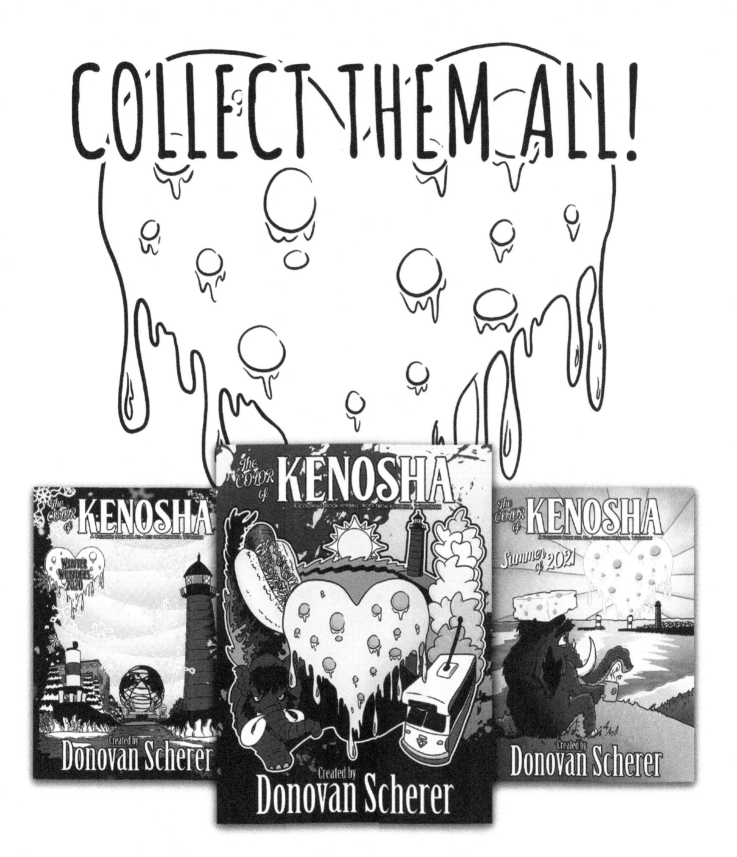

WANT MORE TO COLOR?

FIND YOUR NEXT COLORING BOOK AND MORE AT:
WWW.STUDIOMOONFALL.COM